A Day with
Picasso

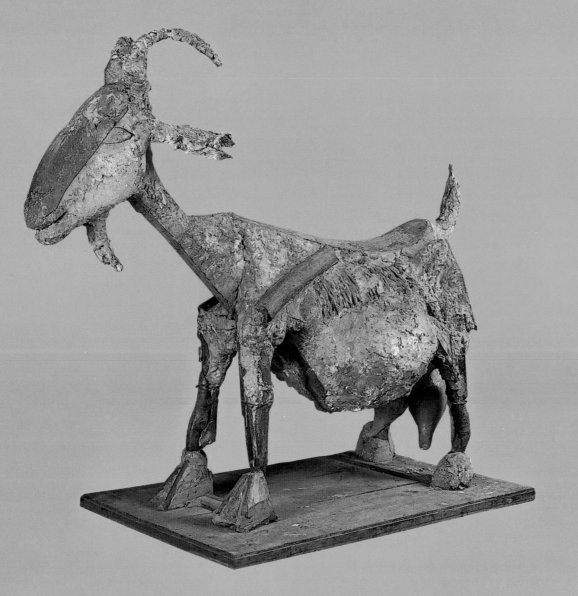

Prestel Munich · London · New York

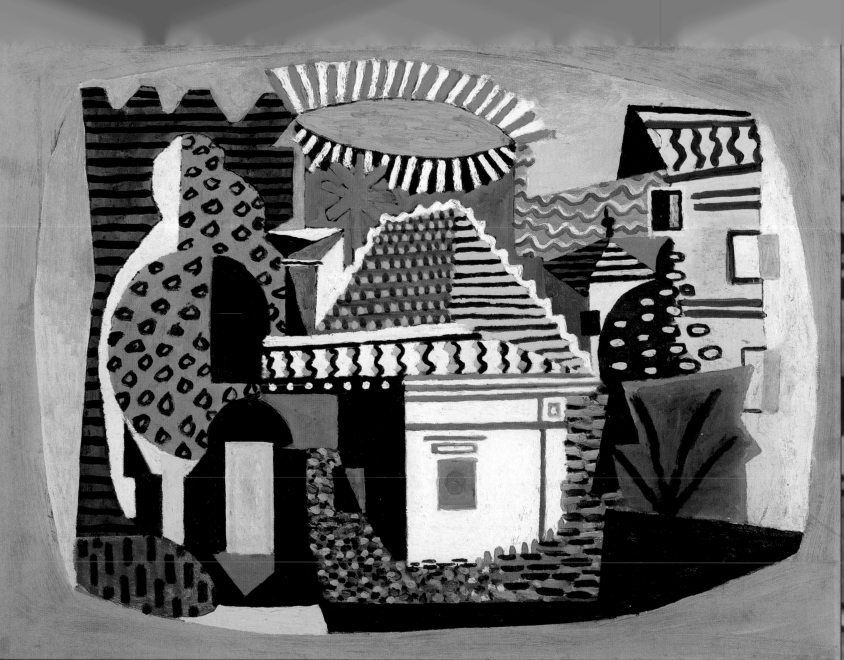

View of Juan-les-Pins

It is a wonderful spring morning at the seaside in the south of France. Everything is bathed in a brilliant light and the blue of the sky and the shimmering sea are a deep azure, a color which has given this stretch of coast its name—the Côte d'Azur.

Up on the hill there is a house surrounded by a large garden. This is where Pablo Picasso lives with his wife, Françoise, and their children, Claude and Paloma.

He hasn't always lived here. In fact, when he was twenty-three years old, Pablo Picasso left his native Spain and headed for Paris where he became an extremely successful artist. Although he loved the turbulent life of the metropolis, he was often only too happy to exchange the cold and gray of the city with the bright skies and warmth of the south.

Picasso likes to stay in bed in the mornings. Today he has decided to sleep in just a little bit longer since he had been working well into the night. He has been trying to capture the blue of the Mediterranean Sea from his window, but up until now he has only been able to produce a few sketches and studies. Picasso is feeling a bit guilty about this too, as he has promised Daniel-Henry Kahnweiler—the owner of the gallery where he sells his paintings—that a new picture would be ready today.

No sooner has Picasso thought about Kahnweiler than he hears his familiar voice in the corridor outside. He quickly buries his head under the sheets hoping that the gallery owner will soon go away if he doesn't see him. But Daniel-Henry Kahnweiler is a very patient and persistent man. He has been dealing with the sale of Picasso's paintings for many years now and knows his friend's moods only too well. He is quite determined not to leave before Picasso has finished the painting that has been ordered.

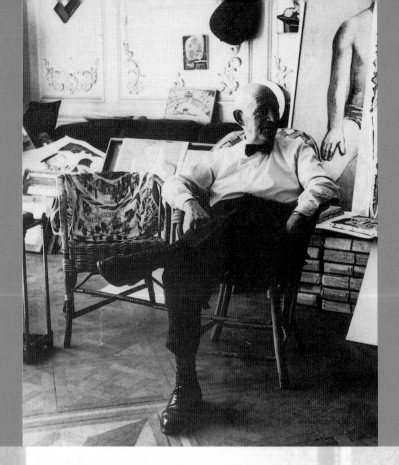

Daniel-Henry Kahnweiler

Soon after the two first met in Paris, Picasso painted an interesting portrait of Kahnweiler. It is made up of different geometrical surfaces, making it look as if the gallery owner's face and the top of his body are divided into lots of separate pieces. Using this technique, Picasso lets us see Kahnweiler from various angles at the same time. This style of painting is now known as Cubism, named after the cube-like, geometrical blocks that give it its character. Cubist artists break their subjects down into different pieces and the then put them back together again in a different way, as you can see in this painting.

4

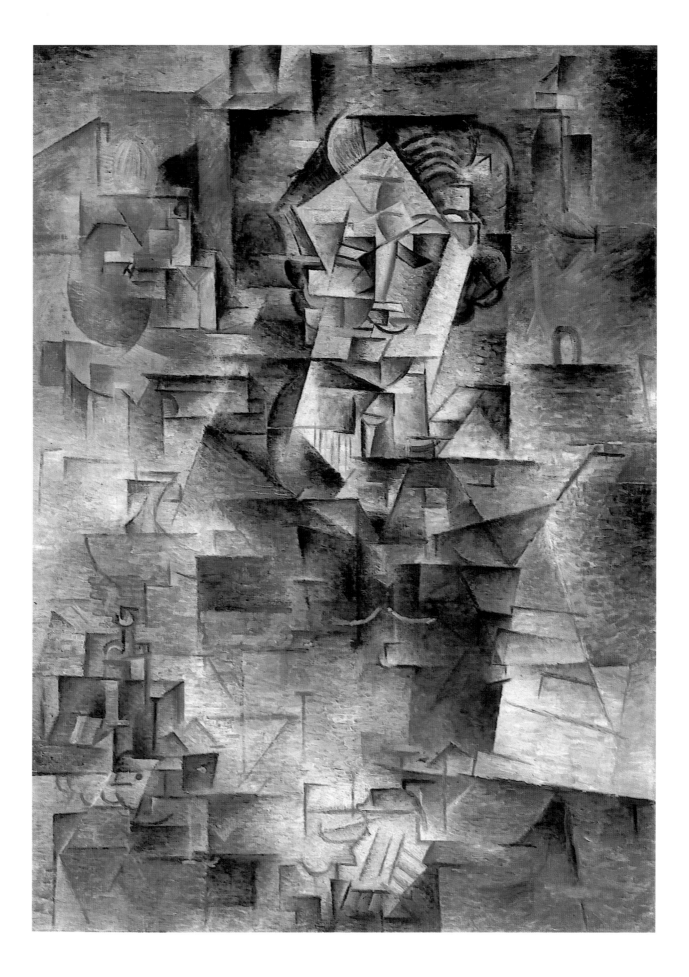

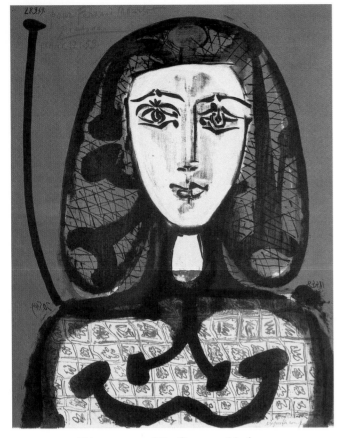

Woman with Green Hair

When he is quiet again she marches to the window and sweeps open the shutters. Françoise knows how difficult it is for her husband to get up in the morning so she always greets him with some good news. She doesn't tell him that Kahnweiler has settled down in the garden for a long wait, but instead she tells him that they have been invited to a big party that evening.

The door to Picasso's bedroom opens quietly, and his wife, Françoise, peeks cautiously around the corner. She is a beautiful woman, and Picasso has painted her many times as a flower. But this morning he is in a particularly bad mood and doesn't want to see even her. Grumbling and mumbling he buries himself further under the sheets. But this does not stop Françoise—after all, she is used to her husband's morning ritual!

6

Françoise

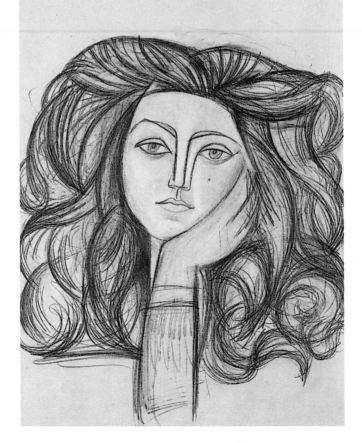

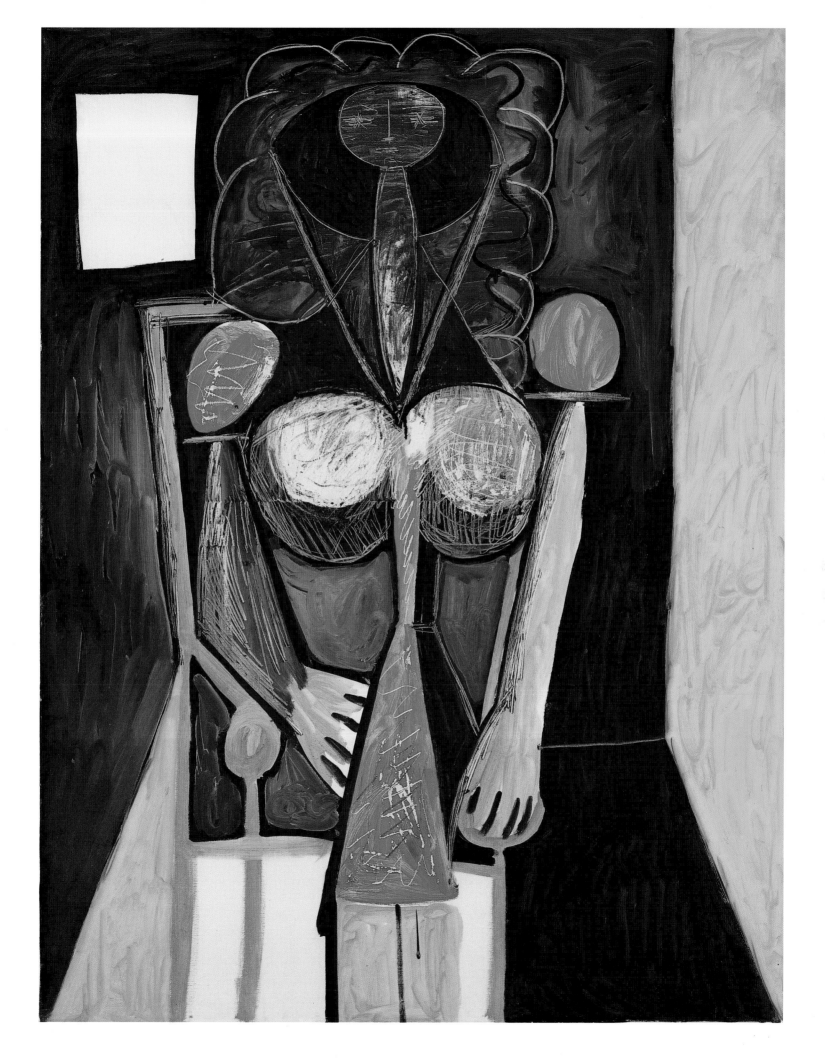

Feast of the Gods

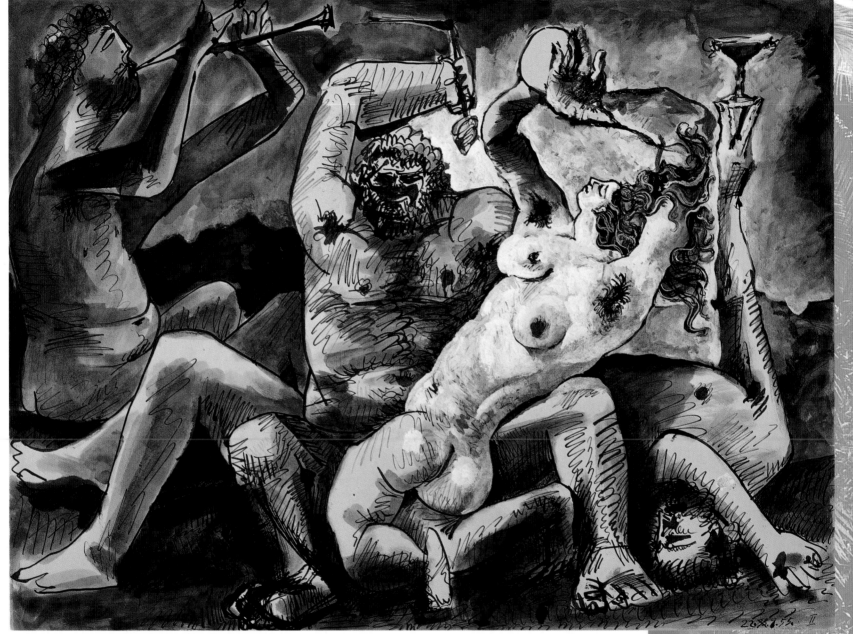

Dancing and Drinking

The thought of a party puts Picasso in a good mood right away. He loves music and dancing and many of his paintings picture daring dancers and cheerful musicians. Picasso starts to imagine the sound of the music and the relaxed laughter of his friends at the party. Eventually these happy thoughts drive him out of bed. Still a bit sleepy, he walks to the window to see what the weather is doing.

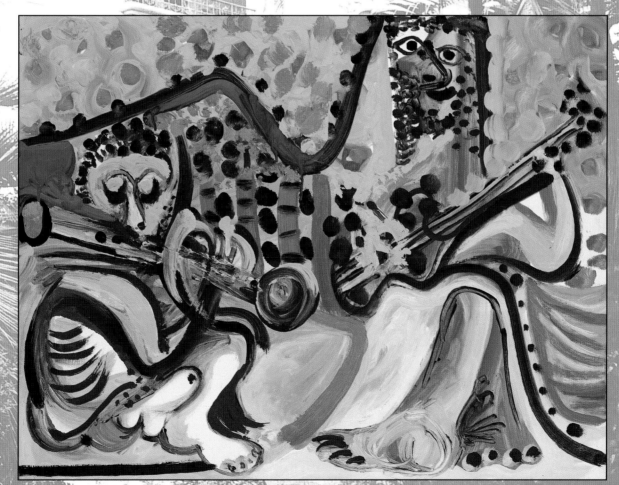

The Musicians

Meanwhile, the sun has risen high in the sky and Picasso is welcomed by the dazzling light of a beautiful day. What a wonderful view of the sea and the sky! As if suddenly filled with a new bout of energy, he forgets his tiredness and his bad mood. There it is in front of his very eyes—the exact motif that he has been looking for! Without bothering to get dressed Picasso hurries into his studio as he is—in his shorts—and begins to paint the view he has just seen. Nobody is to disturb him now. While the artist is at work, everything else around him blurs into the background, as he concentrates on the canvas in front of him, working with intense confidence—as if in a trance. To the right of him there is a small table covered with newspaper which he uses as a palette. Every time he picks up a brush, he wipes it on the newspaper which, after just a short while, is covered with a mass of colored lines and blobs of paint.

Picasso can work on a painting for three to four hours at a time without feeling tired at all. "Whenever I am painting a picture I leave my body outside the room," he once said about himself. Today he is making particularly speedy progress and is painting a number of different versions of the view from the window. Satisfied with his work, Picasso takes a step back to look at the result. "Kahnweiler will be pleased," he thinks to himself, "but I'm only going to give him one of these. I'll keep the others myself." Picasso has never really liked having to part with his pictures.

The Studio

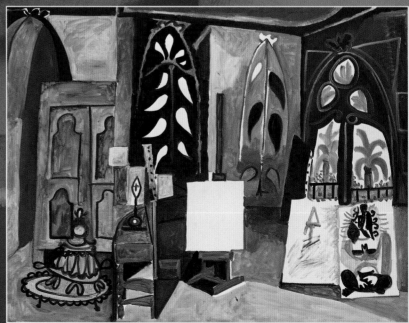

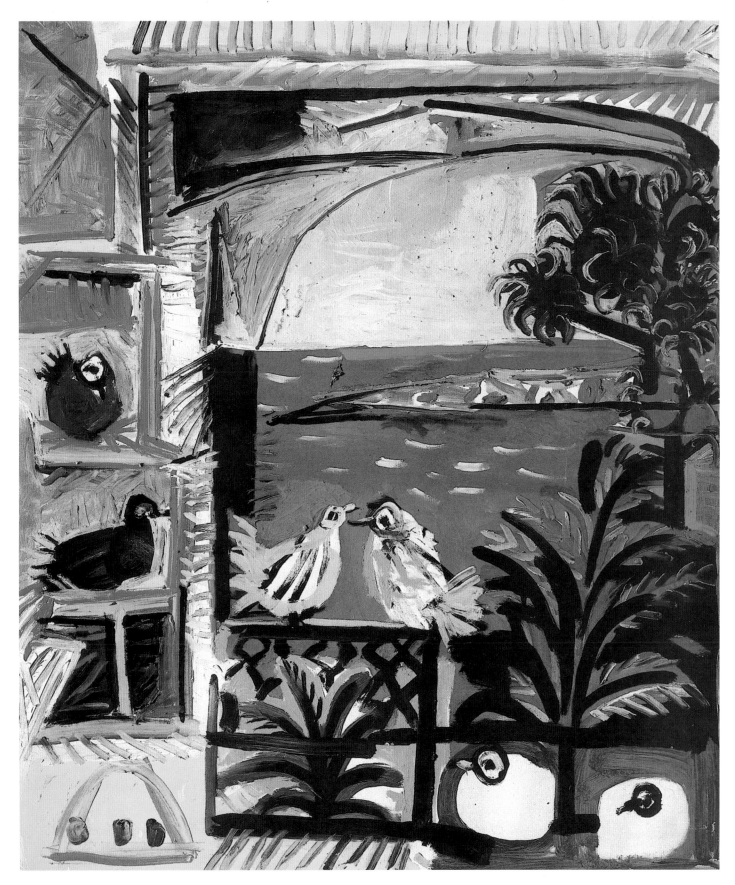

Doves

Without warning, Picasso's stomach starts to grumble and rumble. While lost in his painting he has quite forgotten to join his friends in his favorite little restaurant down in the village. But now he has really left it too late, and so he decides to have a look in the dining room to see if there is anything there to eat.

He goes into the room and his daughter Paloma leaps up to greet him. There is not much left on the table to feed a hungry artist. "There's nothing there to fill me up," he says to Paloma, so she rushes off to find some fruit and cheese in the kitchen for her father. One of the family pets, a dalmatian, simply called "Dog", stays behind with the artist and turns his head towards him, inviting Picasso to stroke him.

Plate with Knife, Fork, and Apple

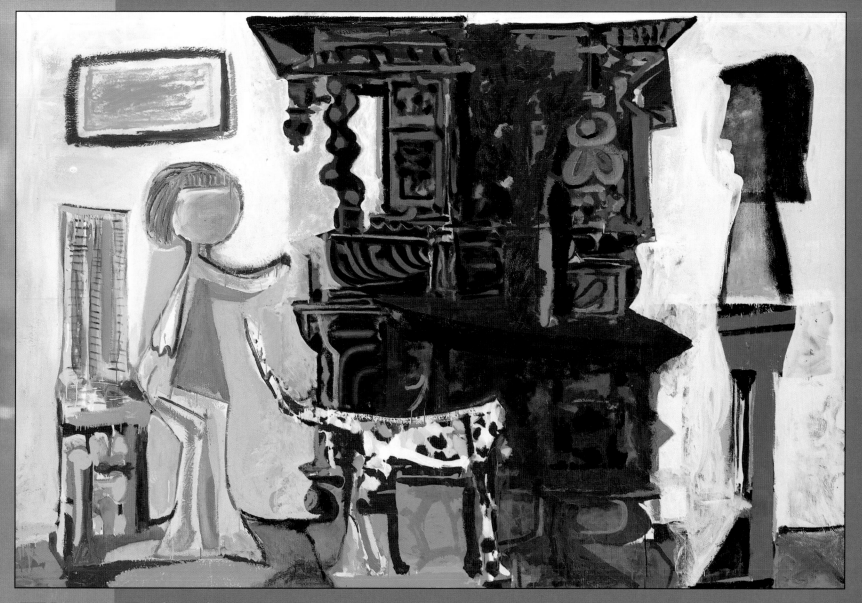

The Dining Room

Bowl with Sardines

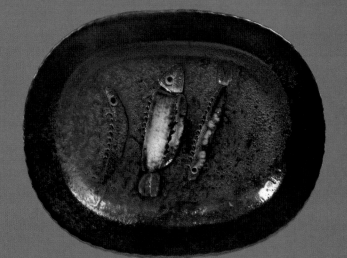

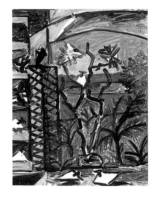

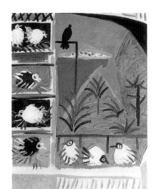

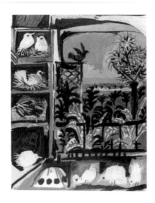

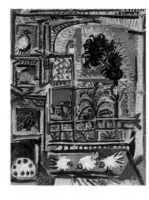

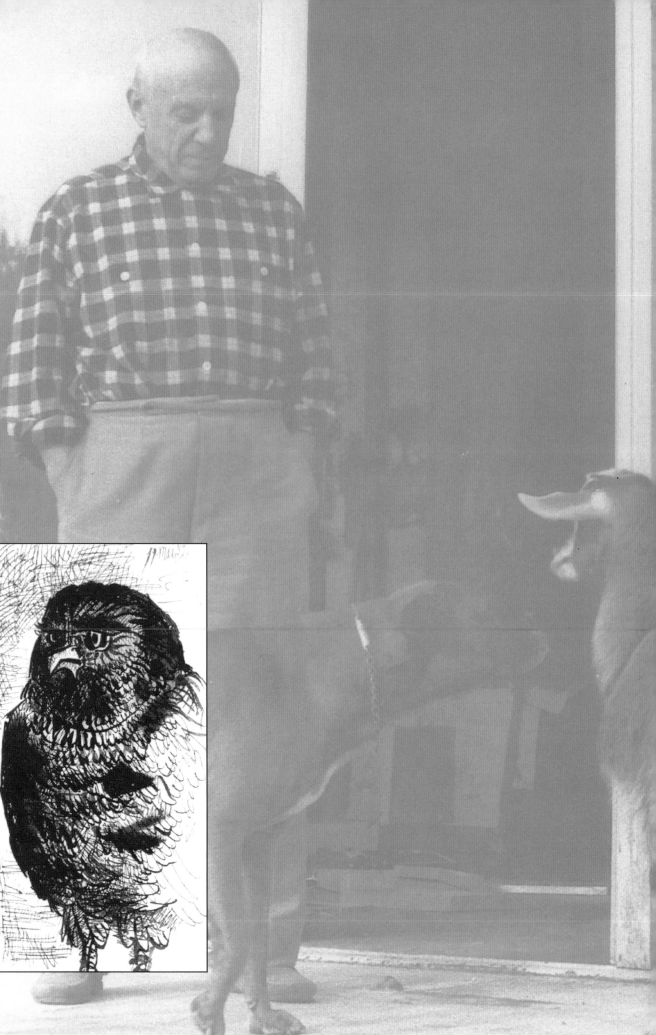

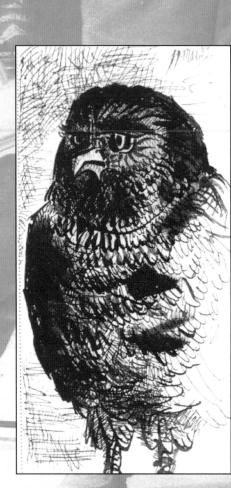

The Goat

Picasso likes animals very much. In fact there is quite a small zoo of animals sharing the house and garden with the family. Apart from the dalmatian, there is a boxer called Yan, Lump the dachshund, a motley assortment of cats, canaries, and turtle-doves, an owl, and the donkeys, whose

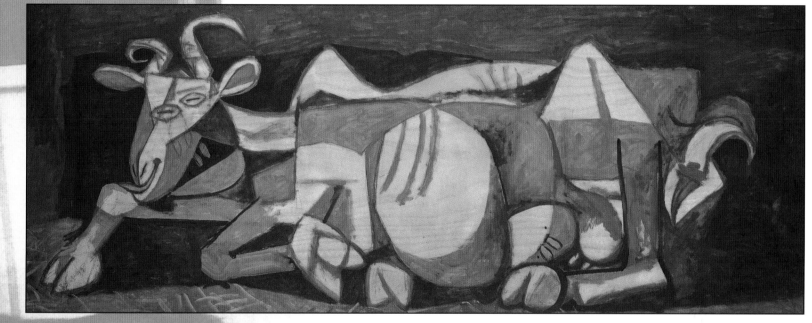

task it is to keep the lawn in check, while the goat, Esmeralda, is allowed to follow Picasso around the house. The artist's four-legged and feathered friends have inspired him to paint a number of different pictures. Even the earliest drawings which he made as a young boy feature doves. Much later one of Picasso's many paintings of doves was to be used as a poster and became world-famous as a symbol for peace.

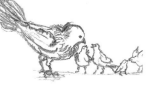

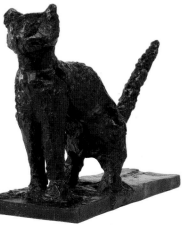

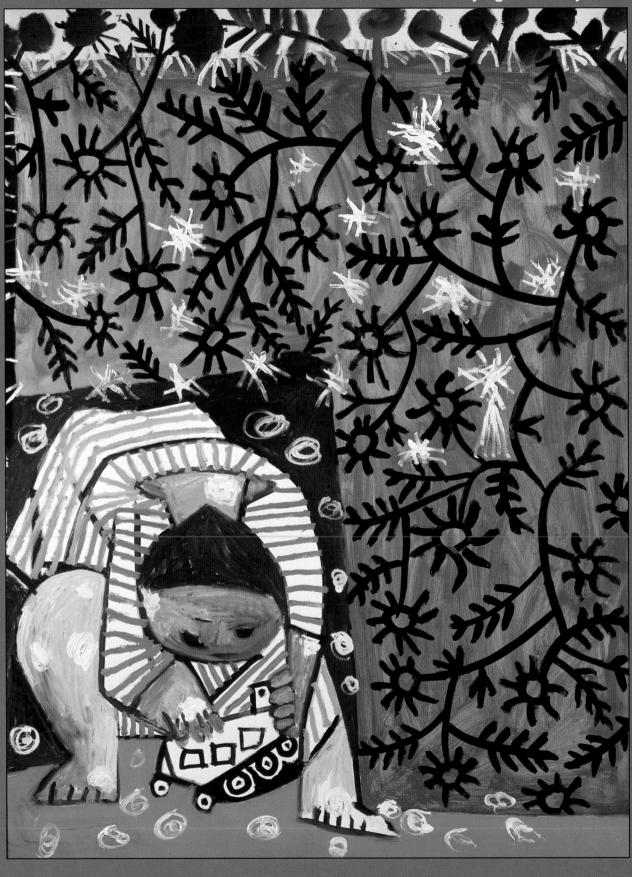

The children like the sculpture of the baboon and its offspring the best, even though Claude was a little upset to start with that his father had taken two of his favorite toy cars to make it. Picasso got the idea when playing with Claude. He set the two cars together so that the gap between them forms the baboon's mouth and the radiator grille makes a mustache. The roof of the top car is the forehead and Picasso fixed two lumps of plaster to the windshields as the animal's eyes.

Everything that Picasso sees, whatever its shape or size, fills him with inspiration for a new sculpture, urging him to embark on a new artistic adventure. He loves to collect the strangest bits and pieces from garbage dumps or from along the highway. He was as pleased as Punch when he came across two broken jug handles which he promptly turned into the baboon's ears. Picasso has great fun surprising people with the unusual origins of the different parts of his sculptures. He wants us to look differently at all the things that we throw away and have long forgotten.

A potbellied jug with handles is used to make the upper part of the baboon's body and shoulders, a door hinge is at the end of the animal's tail, and the little head of the baby baboon was once a ping-pong ball.

Baboon with Offspring

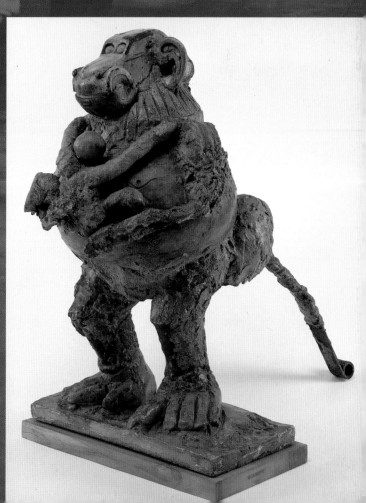

As soon as Picasso finishes the snack which Paloma has given him, he calls his son, Claude, and the three of them start to draw. For Picasso the hours spent drawing with his two children are very important to him. He is fascinated by their carefree enjoyment and by the way they see things. This is something he would like to incorporate in his own work. "When I was a child I painted like a great master, but to be able to paint like the children I'll have to work at it for the rest of my life."

Picasso doesn't have that much time left today for drawing with his children because a person called Sylvette will be coming by later afternoon. He is in the middle of painting her portrait, and Sylvette has been at the house every afternoon for the last few days to sit as his model.

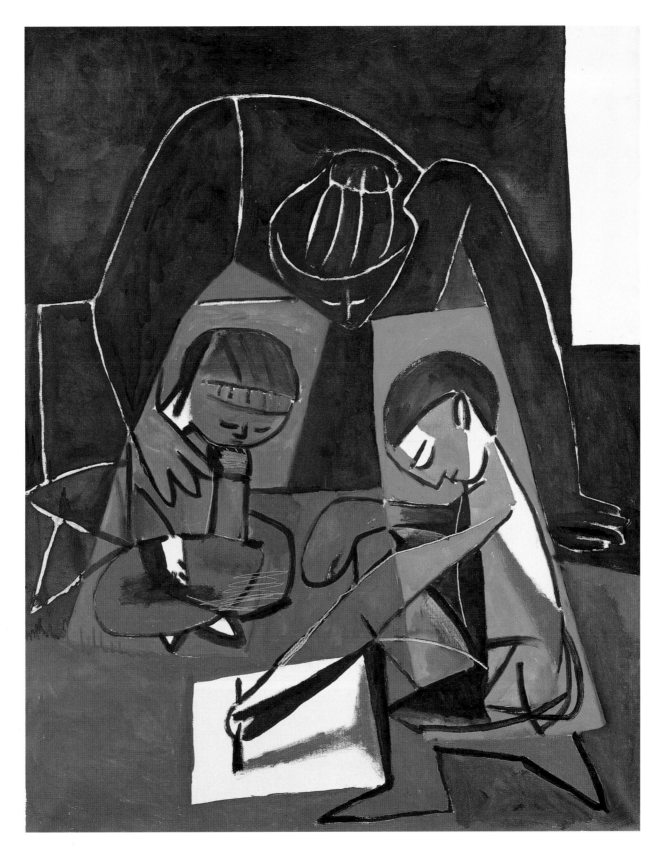

Claude Drawing, with Françoise and Paloma

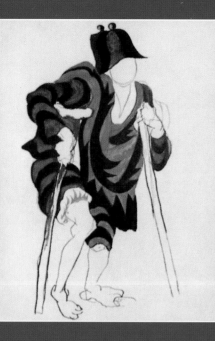

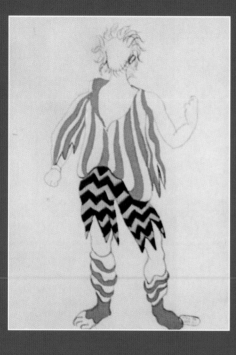

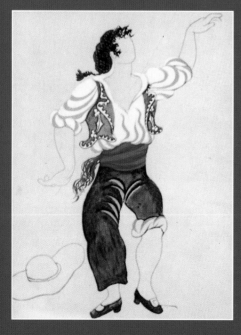

A model has to sit still when being painted, but today Sylvette is particularly restless. She chatters away without a break and is very excited because she has also been invited to the party in the evening. Sylvette tells Picasso that it is a fancy-dress ball and, however hard she tries, she just cannot think of anything original to wear. Picasso finds this all very funny because he loves to dress up and has a whole collection of fantastic costumes.

When he was in Paris, Picasso designed costumes and stage sets for lots of theater productions. He shows Sylvette some of his costume drawings and tells her to choose one. She picks out the elegant dress of a Spanish dancer with an unusual towering headpiece and runs off home as pleased as she could be. Picasso doesn't have to think hard about his disguise: he intends to go as a bull. Only recently he has been given a mask made of wickerwork for his collection in the shape of a bull's head.

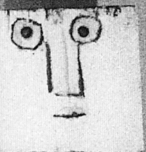

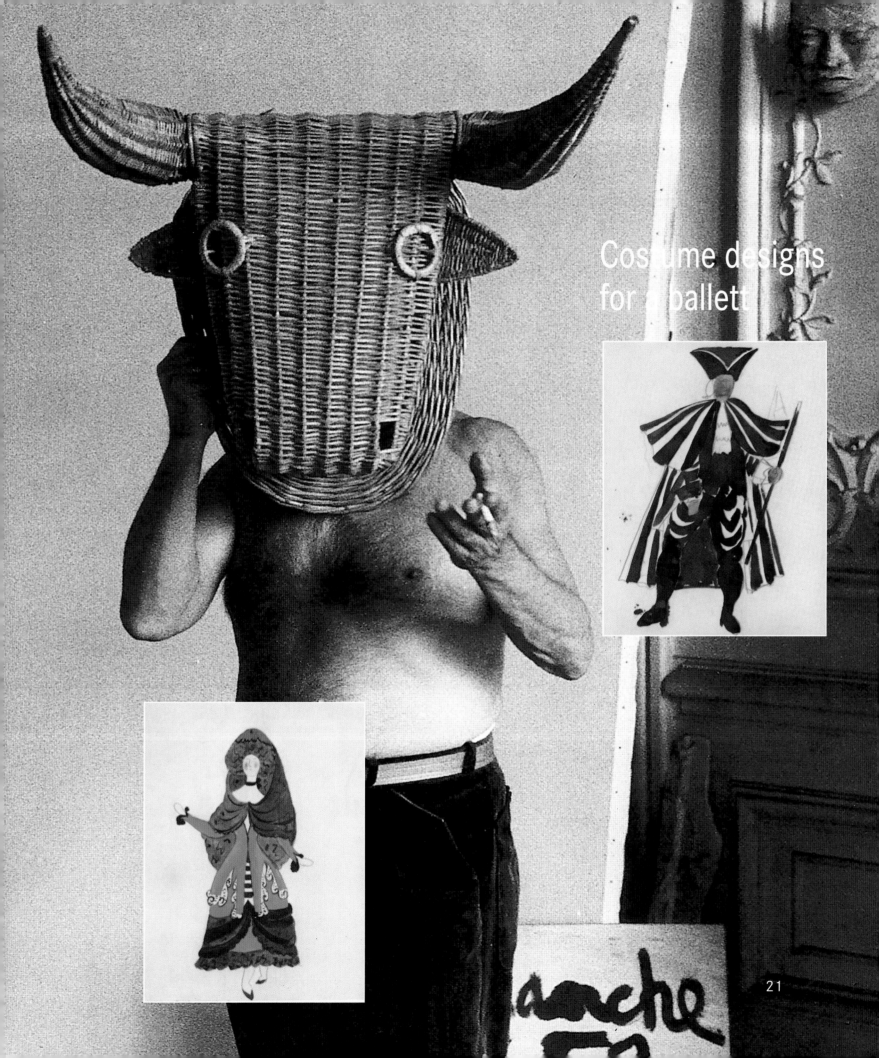

Costume designs
for a ballett

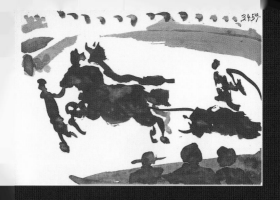

For Picasso the bull has a very special meaning. He sees it as a symbol of strength and manliness. Like many Spaniards, Picasso shares a passion for bullfights with the bull and the matador playing the leading roles. He often takes his whole family off on Sundays to the nearby towns of Nîmes or Arles to watch a *corrida*—or bull-fight.

Picasso's village of Villauris still holds a bullfight every year to honor their famous artist.

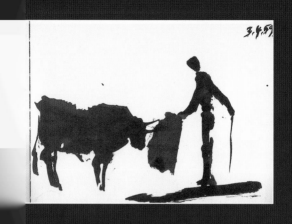

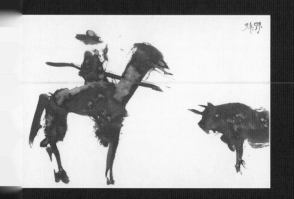

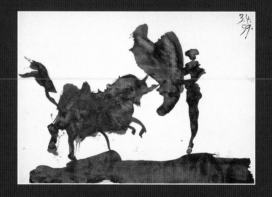

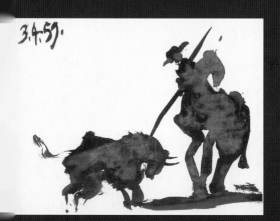

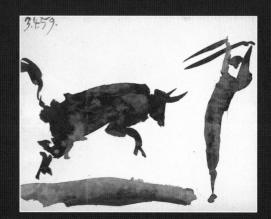

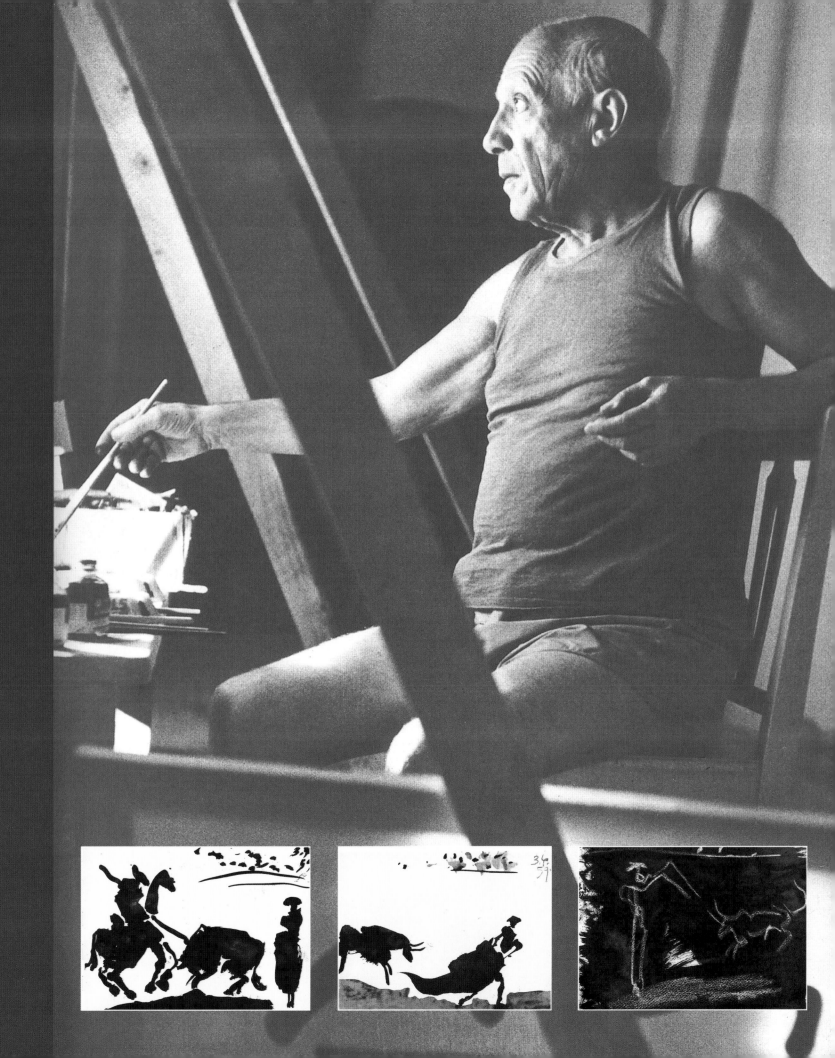

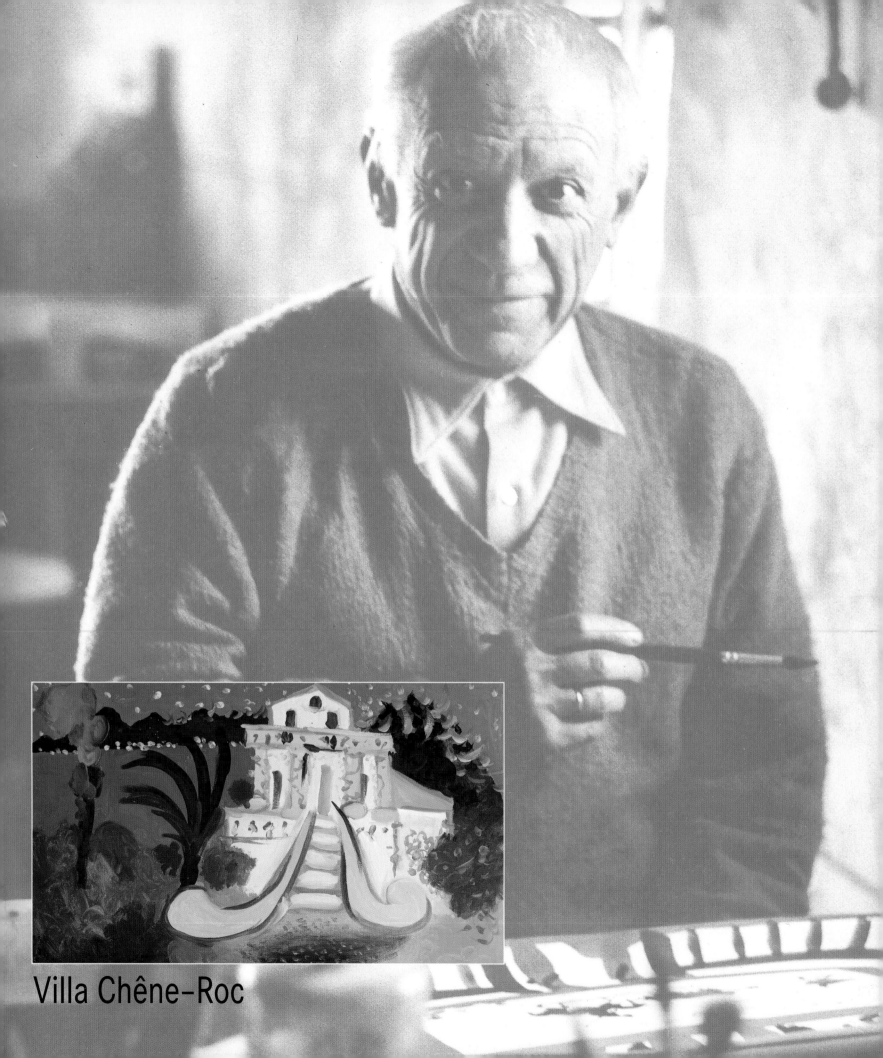

Villa Chêne-Roc

It's now getting late and Picasso goes off to look for Françoise. In the garden he comes across Daniel-Henry Kahnweiler who, after waiting and waiting for Picasso, has fallen fast asleep in the chair. Picasso decides not to wake him up because he wants to surprise him tomorrow with his beautiful new painting.

Women at their Toilette

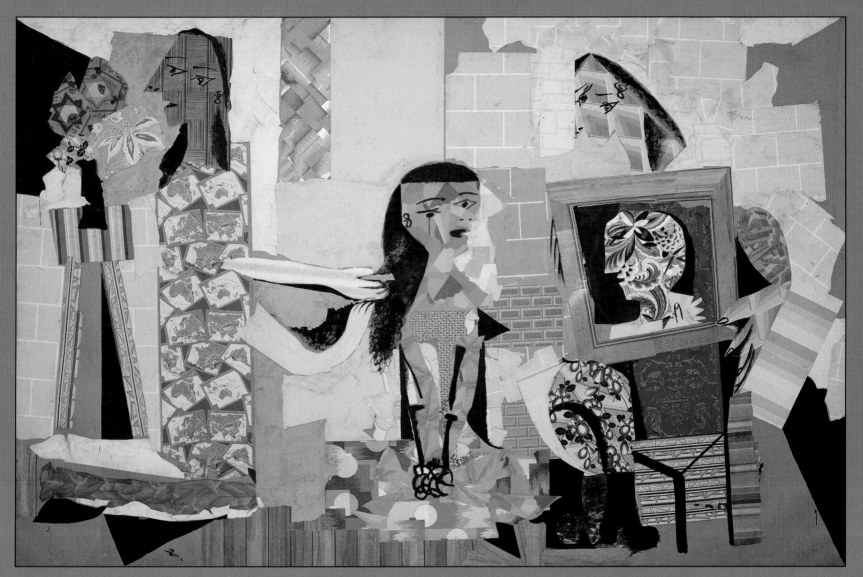

So as not to disturb the sleeping gallery owner, Picasso tiptoes past as quietly as possible.

He finally finds Françoise in the dressing room where she is wondering about how best to tie up her long hair. "Are you nearly ready?" calls Picasso. "You don't need to do look so horrified at yourself in the mirror! You look stunning with your hair loose. Come on. Let's get going, or we'll be late!"

Picasso and Françoise go off to the party where they see many people they know well. The sky is clear above the Côte d'Azur and the stars are shining brightly. The party is in full swing and they dance and laugh the night away with their friends.

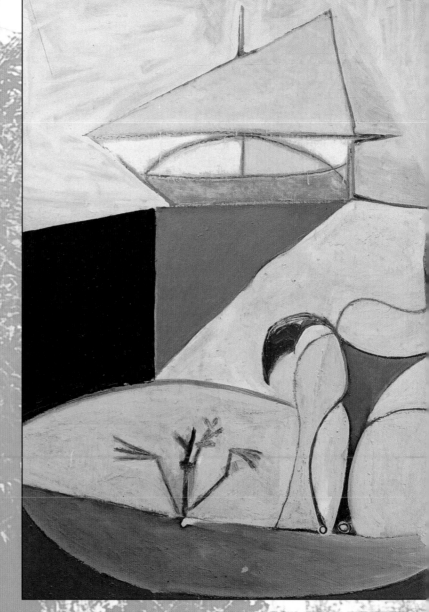

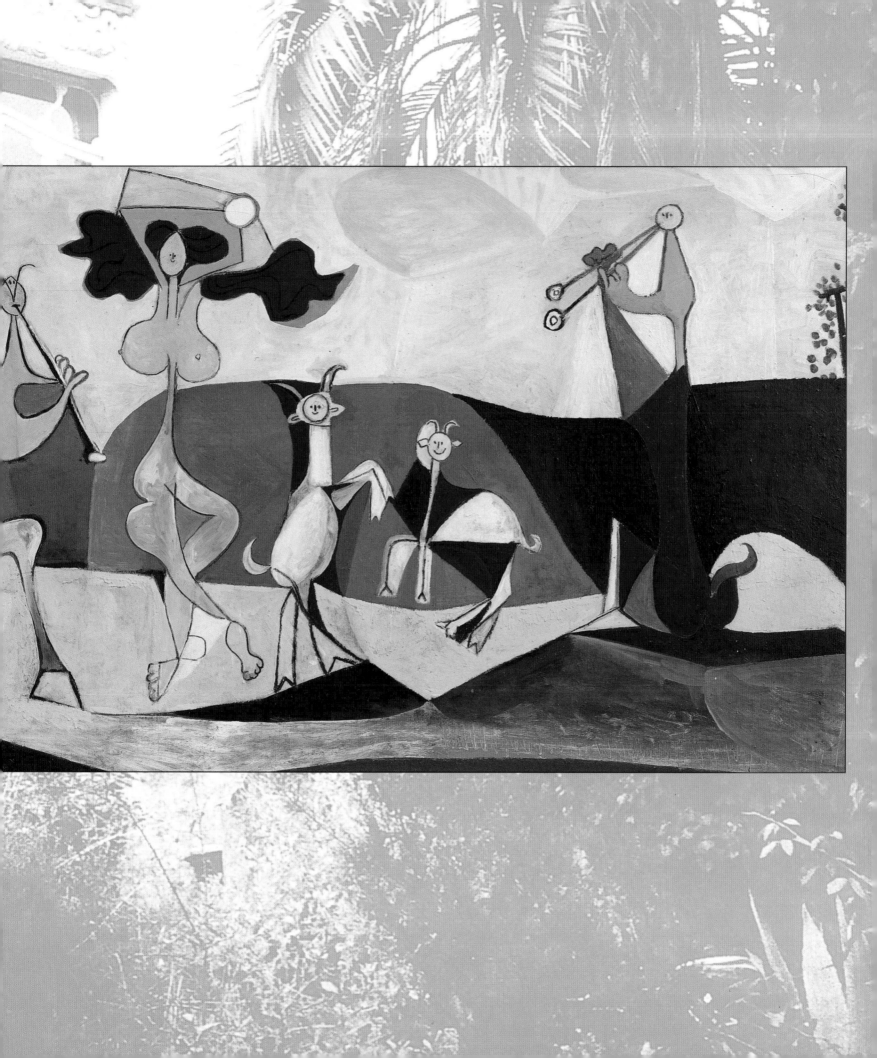

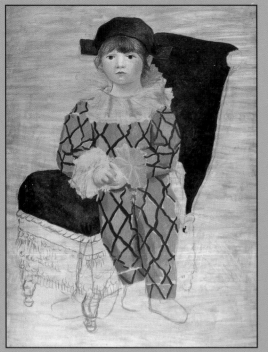

Paolo as Harlequin

Picasso's Life

Maya

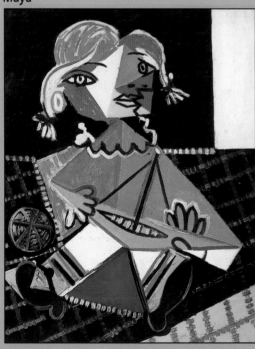

Pablo is born in Málaga, Spain, in 1881, as the first child of José Ruiz Blasco and María Picasso y Lopez.

Pablo Picasso starts to paint when he is ten years old. He is exceptionally talented and passes all his exams at the academy of art with flying colors. The first exhibitions of his paintings are held in Barcelona, Madrid, and Paris.

In 1904 he goes to Paris where he rents a studio.

He meets the artist Georges Braque in 1907, and together they create the artistic movement called Cubism (see page 4).

In 1918 he marries the dancer Olga Kochlowa with whom he has a son called Paul, born in 1921.

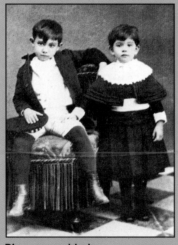

Picasso and Lola

He meets Marie-Thérèse Walter for the first time in 1927 and paints many portraits of her. He leaves his wife Olga and lives together with Marie-Thérèse. Their daughter, Maya, is born in 1935. In 1936 the artist and photographer Dora Maar becomes his mistress.

Picasso paints his famous picture *Guernica* in 1937, which addresses the horror of the Spanish civil war.

In 1947 Picasso moves to Vallauris with his new partner, Françoise Gilot. She is a young artist who has helped Picasso on a number of his paintings. Picasso sets up a studio in Vallauris and starts working in ceramics. Their son, Claude, is born, followed by their daughter, Paloma, in 1949.

Picasso meets Jacqueline Rocque, who he is to marry in 1961. They move to Mougins.

Claude and Paloma

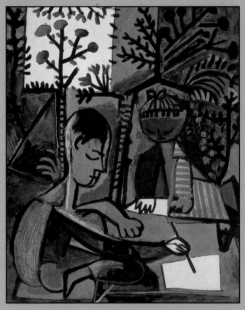

Picasso continues painting right up until his death in 1973 at the age of 91. Both during his life and after his death countless exhibitions of his work have been staged around the globe.

Picasso is one of the most famous artists in the world, and worked intensively throughout his whole life, producing a vast number of paintings at an incredible rate.

When he died he left thousands of works. Part of this huge legacy can now be seen in the museum that was founded in his honor—in the Musée Picasso in Paris.